T0161015

SIGN LANGUAGE
A PAINTER'S NOTEBOOK

JOHN S. PAUL

THREE ROOMS PRESS

NEW YORK

THREEROOMSPRESS.COM

First Edition

ISBN: 978-1-941110-04-1
Library of Congress Control Number: 2014937999

COVER PHOTO:
John S. Paul
johnpaulpaintings.com

COVER AND INTERIOR DESIGN:
KG Design International
katgeorges.com

PUBLISHED BY:
Three Rooms Press, New York, NY
threeroomspress.com
facebook.com/threeroomspress

DISTRIBUTED BY:
PGW/Perseus
pgw.com

To Dan Gillham

and the

Golden Girls

SIGN LANGUAGE

contents

WISH YOU WERE HERE

An Introduction

ALTHOUGH WHAT FOLLOWS IS largely a collection of poems, it is important to keep in mind from the outset that John S. Paul is primarily a painter. A painter of lush narrative canvases, portrait sketches, and genre scenes, as well as a painter of billboards and movie scenery, and with language, he is a limner of a life lived in New York City. Few painters have the range that Paul has, and fewer still possess the economy of language combined with the rich visual textures that give his poetry the feel of a documentary. One is tempted to compare his work to Dos Passos, or maybe Ferlinghetti, while at the same time the cinematic drama and pathos of Hertzog comes to mind.

That these stories are collected under the title Sign Language has its own sense of poetry. Sign language uses gesture and physicality to replace speech and sound. Much like semaphore, it is a language that abstracts the spoken word. In essence, what joins together the work of Paul is his use of image and written word; the narratives of his paintings are often oblique, but his poetry nails down small moments—tiny gestures—with precision.

Music is a factor in Paul's work. When he talks about it he illuminates a great deal about his philosophy of art. "Music? That's a hobby, and if it ever gets into my work like it did for Romare Bearden, that would be natural. To play jazz means to wade or swim in a stream of heroes. There are no more exemplary artists than the players and composers of modern music. If you know a tune well enough to improvise, you have an inner reference and calm much like dreaming. Take that to the next level?

Perform with others? You have to want that like the footballer wants to score a goal. It's another language structure—free but with rules. You need to know the rules. I'll always be a beginner as a tenor sax player, so I concentrate on tone and sound." Tone and sound, like texture or light are the poetry of the abstract. Chance, accident, happening to be in the wrong place at the wrong time: these are the things that make life interesting.

Cormac McCarthy wrote, "If it doesn't concern life and death, it's not interesting." Paul's poems, such as "Cubism Today," a meditation on a lunch break on a busy workday, lend some credibility to that notion. For what are lives lived, or measured by, if not by hundreds of bowls of mussels, thousands of cigarettes, countless glasses of wine, untold empty Bud bottles, and uncountable sandwiches eaten while leaning against a scaffold on a hot sidewalk? Paul documents the variety to be found in the overlooked, and this is what a painter does. His narratives are simple, concise stories from a man who practices his art both in public (sign writing) and private (painting), all the while keeping track of the moments when these activities happened.

Socrates said, "The unexamined life is not worth living," but an unlived life is not worth examining. Paul has managed a high wire act, both exploring and documenting his existence with grace and poetry, and, like a good tightrope walker, has done it without a net. If these poems make that act look easy, it is because he has done it so well.

—*Bradley Rubenstein*

Bradley Rubenstein is a painter and writer who lives and works in Brooklyn, New York.

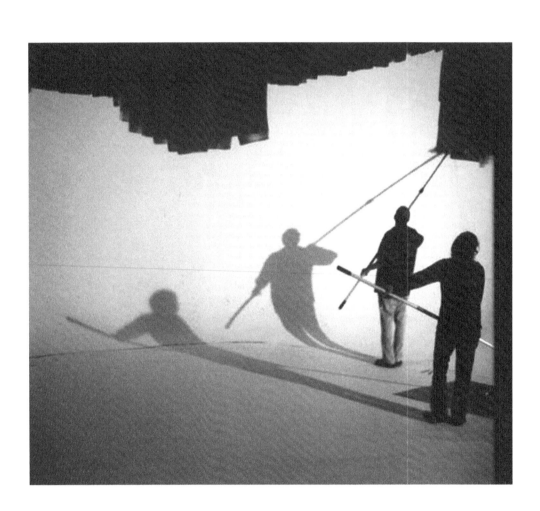

HYBRID

I can't say what it's like
except if you were not a proper
trained electrician
and wanted to splice
outlet wires
into an electric box
in the basement of a city tower
without yellow kitchen gloves,
you would run the risk
of shutting down the building lights,
the elevator, and maybe cook your aorta
like a boiled beef heart.

The typewriter is a safer tool, the only danger
is time lost not found.

But let's not overlook
how our friendly botanist
succeeds with a new strain
grafting a hybrid to magnolia trees,
that now enjoy his name.

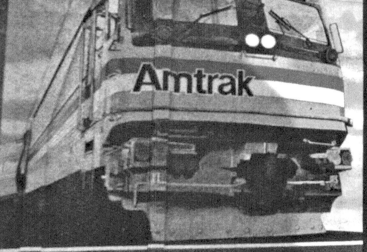

COURTSHIP AND THE TOWER

A young woman was dragging
her suitcase in the Maida Vale
coaxing it, an obstinate thing. I offered help
for the short walk to Paddington
my service a smile and a gallant farewell.
There was a phone number collected
but no further assistance
in those candied days.
I knew who I was, who I came for,
how I landed for her, watching the rumps
of the Royal Horses parading near Buckingham
one morning late, having missed the punctual first plane.

Love was a bedsit with our freedom.
We lived wholly on bread and butter—good cheese
slept on clean lavender sheets. The years arrived on time
as my own suitcase became filled with old clothes
stained with warpaint—my hair shirts of battle.
A young man travels light. I could be exalted in winter
carried high on winches without ceremony.

I arrived at this tower of rusty plumbing and cooking smells.
Later I found my feet, tethered in harness
in a rough brotherhood—a new man!
The tower was our joke—fearfully funny
as if we had taken a grim oath—danger
just a step away. The wind had keys
to a string of towers like these
and in February we swung down
the side to cover our asses. On warmer days
we saw the dirty January ice
melt and puddle into watercolor.

Intact we floated in the updrafts of fried foods
over 34th Street as I laughed and painted, my helper
leaning on the rail, watching the girls crossing streets
and I too took a glance at the bright show below.

BREAKFAST ON MARS
(THE OUTDOORS REVISITED)

7:30 sharp, the gates roll up
the world outdoors
is getting late—we spy the weather
with foxy eyes—speculate
like thieves against the sun.

It's the nineteenth hole in golf
that keeps his mind from disarray.
Position key—Joe would say
be careful but not too careful.

Would-be child of paradise
blessed with wife and child
join the fray of painters,
paint Outdoors!

On the roof facing the highway
stands my blank canvas
framed by iron on stilts—jacked into the sky
old as hills. The pay is good
I revel in the blue collar
milkman mailman life—wandering
the city—home for dinner
Wonder Bread on the table
Bud at the bar.

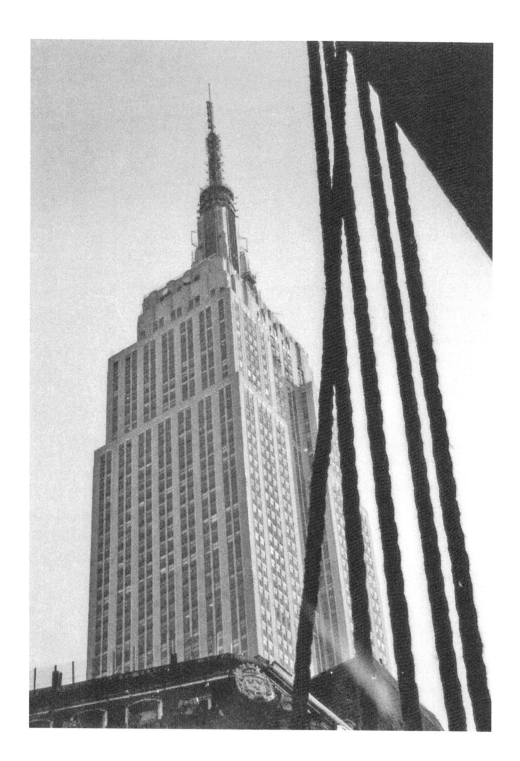

That factory went belly up
from three shifts to ghost
but we kept the signs on top
remembering the heyday
where a hundred men punched in
to run the presses and lathes,
the din designed to hurt your head
endure the sin of boots and grease
no bromide for the night shift
their footsteps now a hollow echo.

We climb those stairs
to do our work, haul up ladders
coils of block and fall
the oiled manila rope with cactus spines
the rainbow in gallon pails.

And when we reach the top,
we take our time among the pigeon coops
the giant latticework
of the gas tanks, loiter like felons,
pose and smoke like pimps
nurse our coffee and hold off
for a minute more, enjoy the shade and air—
then think belatedly—look out!
Today at lunch—on this very savage roof
maybe Joe will come, himself!

Our early breakfast feeds the plan
to mount the big white sign—
I dwell inside a joke
of how to show in paint
that pleasure comes
from something you should buy
it's cold, it's hot, it's what you need
to be a man or how a lady
wants to shape
her busy day, or be assured
you truly care. The letters must be level-
crisp. The agency may send a man to watch.
Some time after 8 a.m. we climb up.

* * *

Nor omit the giant wall
on 34th Street, twenty-three stories
tall, of blind façade—a challenge so
preposterous. We ascend on wire rope
press the button to go up motorized
walk the plank—a slim rail at our back
the scrolling bricks in front.
We do our trick invisibly free
soaring in a climate change
float like cellophane in an updraft
where shadows from cooler swarms
mingle colliding with hot—
masonry skimmed in long shadows, noon.

In burlesque we slide down ropes
in sailor suits—on Broadway
to paint a follies, a marquee.
From a bird's eye view—up there
sheer legs of women move
across the sidewalk dunes
in nylons and spike heels—
with a svelte lurch and purpose
hurry through the heat like a camel
to a showroom, a carpeted oasis
far from the egg-yolk sun.

Look up! The big signs
painted by busy dreamers
calculating schemers
our legs and brush hands
poised to plant the flag
for a snappy foreign car
celebrate a big orange drink
burnish a legend
for an exact Japanese camera,
blow up the syndicated funny-pictures laughing
on generous ice, martyr the full effect of Scotch
make redder a pair of smiling lips to kiss
to play her happy status over an abyss—
we soften a serpentine of smoke.

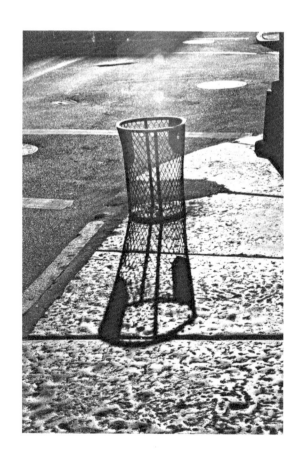

SOUVENIR FOR JOE

Burnt, Sicilian (his father in the open box
at 92) nut brown skin parchment thin
downsized by death and beautified.
I was a new hand on the crew
thought attending was the right thing to do.

Joe, the son,
stood relaxed by pleasure
alert from the farming in the air
flung up by ambition and the bucks
trading in the mainstream
of giant signs and shapes
high above the city's eyes
said a son's goodbye.

The souvenir—a dented flagpole globe
tarnished brass—two hemispheres
crimped by metal craft into a whole
had served its time—the orb got old
parted from the rotting wooden mast
and other wreckage and debris
high above Herald Square

then it slept forgotten in a rooftop drain
tarnished, blind where it had seen
the passage of the crowds
all those lives below—they threaded ways
to Macy's, Gimbels to a Broadway show.
A novel piece of junk—of no value
except a phantom glim of history.

He'll tell you about Fort Bragg
how he beat the rebels shimming up a pole
then reached the tip, stood stock still

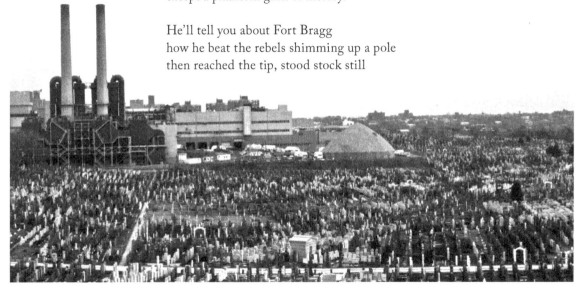

like Nelson in Trafalgar
his back to Piccadilly's ragged time
the mob's surge with a verve of lovers—
he in sergeant's stripes and khaki—
a parade of marching feet—dust
settled on the leaves of London trees,
a marching band in booming brass.

Even now I ask
where did he get such balls
such confidence?

Braggadocio to his men:
when I start a job
it's in my head,
I see it finished.

I was the strange bedfellow
among the hands that drifted through
and he was often fair.

* * *

Epilogue: work first made us friends,
then enemies. Jobs trickled out
painting outdoors peaked
then receded as a way of life.

We saw it coming.

Once high up, painting another outskirt sign
I'd glance down at the sidewalk minding the drips
from the bird's view saw two men
the head-shapes and whorl of hair a match—
a father, son—the agility the same in both
one man robust in frost but older
in ordinary business dress
each right hand staying the other's shoulder.
They stood for a minute in a bond
concentrating before parting.

Maybe then I knew I'd leave the scaffold world—
quit the bad habit of hanging out
over the street on ropes—
but could never known just when.

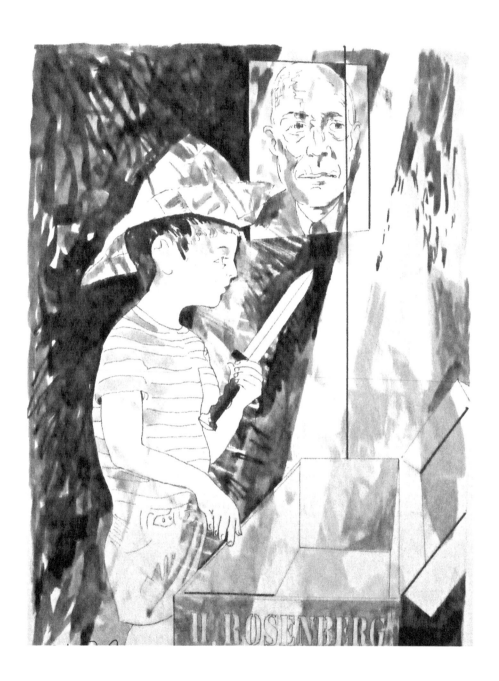

THE GREEN FOOTLOCKER

Those big eyes I had
were coy and winked at Grandpa—
one morning in Omaha—
as he shaved in the bathroom
he smiled and made much over me
anointed and shaped with a fat comb
those baby curls into advanced pomade
with that famous oil—"The real McCoy!"

In their house were pictures
of the early life of Mom
tanned from Lake Okoboji—
here's a jolt: just then
she's not my mom—not Freudian but
still cute and friendly.

Dramatic, Uncle's puncheon ZBT frat paddle
hung prize-like from its thong
in the garret—of ominous use
in hazing pledges' butts—
a souvenir of Punch and Judy
(Willard had to work that turnstile
single file).

Later as a Truman-era
Freudian, horny lumps appeared
on his forehead—seen
by bumpkin farm boys and rednecks
at Fort Benning, Georgia.
He said an Army Jew
was always under a cloud
then after A-bomb treason
from the Rosenbergs it got worse.

My boredom led me to invent
the mystery of the basement.
I went downstairs among clay pots
the man's abandoned bench

a woman's washboard in a tub
with a hand-crank wringer
for the help to use
before the Whirlpool helped the help
but the only worthy find
was one green footlocker, empty

save for a greased unused
New Army bayonet
for one of Ike's pledges
(Uncle was lucky to save his own skin)
the sharp point addressed
to no one personal.

I still sit here, stream abstracts
field conduct profiles, ambush
fake confessions that my mother wrote
for the women's magazines
and ask myself again
how on this earth to make the grade.

BY TRAIN

By train on trips with Mom my brother Rob and I
got our elbows tangled in the shoe net
of a Pullman berth from Chicago to Omaha.
Ecstatic we whispered and peered out
into a wash of indigo—
but in these shaggy trees made out
the likely bulk of herds—wild as history
the ghosts of grazing buffaloes.

On trains to follow once out west
or south in youth, to Mexico—sat up in coach
for days on end—through Alabama
smeared by night, chatted with a communicant
then dropped off in a throbbing lullaby.

In the observation car, woke up
to a capsule vaulted blue, a sapphire dome
misted from our breath. Travelers singly stirred
in mystified civilities. Like dogs men shook off chill
and then emerged solidified, their destination sure.

A woman stretched from her waist aspiring
to a choir. We rode in tacit unity—dawn bounding
from our Star—proud silos standing self-proclaimed
amid the country's souls, an honored pageantry,
low hills passed by in rows.

We walked with hunger through these cars
and minded vestibules with care, shaken in a cage.
The cold came in successfully
you felt it in your toes. The dining car was impeccable
crystal with a rose—the scene exists in tremolo—
the double-standard grin
a darker man who smiled both times
for you and then for him.

The low hills passed and dodged away
the breadth of scene I scoured
searched and failed to comprehend
how we're so near so far

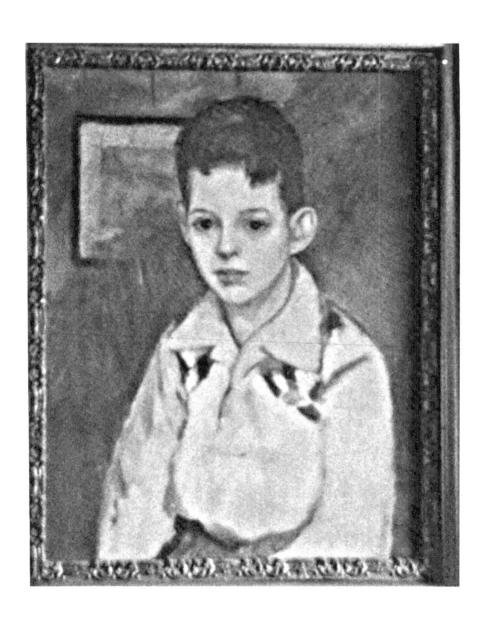

HOT

Tea if it is to be tea
is best served hot—just off the boil.
Some can sip right from the spout
others smile and wait
till the urgency is gone
as molecules slow down.

My wife drinks her tea straight
and her tongue doesn't scorch
my cup settles
we're old friends.

At Christmas time (I was ten)
one of my gifts under the tree
was a wood-burning set, really a toy
soldering iron designed to char
a line into samples of soft wood—
ready to plug into an outlet. The templates
were for boys—scenes of pioneers,
Indians, seafaring men. My small hand
got loose with the hot pen
and touched Grandpa Walter
who was close, watching me—
I nicked his knuckle. He said ouch
but it was minor, as with the hot ash
of a cigarette. He smiled—I was sorry
and we kept playing
but I knew then
he had a special resistance to things hot.

It always seemed we were easy friends
since they lived remote in Omaha, far away
making no demands, didn't need the job
of correction. Hemingway said there's more love
when you skip and loved his grandsire more, but his dad
was a prick and disapproved of Ernest's art.

One summer I was riding alone with Walter in his bronze Buick
over the corn-furrowed hills—unrestrained by the future
of safety belts. He was smoking a cigar.
I could barely see over the dashboard
but in my sights was some official sticker
that had been scorched past shrivel barely clinging
to the glass—blistered by the Nebraska sun.
Unchecked, I scratched at it like a cat
and Grandpa changed from happy to adult:
Hey kid whadaya doin'? I hadn't learned yet not to touch
something when it looked too easy.
He wore a three day growth like Nixon
and boy that day was
a hot one.

NOTHING IS WRONG

Once I flung a roofing tile absentmindedly
into the innocent blue sky to show
my younger tow-headed friend
what a boomerang was and how it worked.
So it went out, hung, came back
and struck him in the temple.

His red blood against a blanched brow
leaking through small fingers shocked me.
My little buddy small and pale in his white T-shirt
raised my concern and pity—some fear of
consequence? As I walked him home I knew
his dad had been stationed in the Pacific—
Okinawa—a place for soldiers, sailors, airmen—
this was Korea time I can't assume
what duty he had done but
I was embarrassed. Knowing now
this was a play mishap it was also
my first act of responsibility—escorting him
and standing the charge as if the injury
was deliberate, which in a roundabout way
it was. To us weaponry was abstract fun.

Jump to my loophole exit from Vietnam
disabled by exploding soda bottles
trauma to my left cornea, that
occurred just before my number was up.
In stories we know soldiers came home—
some to work in departments, rejoin wives,
attend rotary clubs, seek political office
the personal life a platform of rituals
insignia, codes, apotheosis of the fallen,
the flag, in relic triangular fold, sacred.

In this now tide of carelessness and ruin
whole families and beautiful isolated souls
are washed out from their shelters
shrines of happy photos and mementoes
packed into storage
and yard-sale auctions
the worry to sleep, the problems of hygiene
the living in vans and cars—
somehow they endure.

* * *

There is a photo in my sister's garage
of my brother Robert, taken on his ninth birthday
by our famous friend, Archie Lieberman.
Now in mind's eye a portrait of a boy
with a wonderful smile. He disregards
for an instant the undertow of defeat
the violence of a dad with blind migraines
and bad drinking—a beautiful and passive mom
the deficit of love against him—
so he looks up to a white cloud above
where he is a comic star
on TV with a wide following.
The photographer made highlight dots
with a white pencil on each beautiful round eye
like a painter might in a finishing touch—
Rockwell or John Singer Sargent say.
What is wrong with this picture?
Nothing is wrong.

PUSSYCAT

In the uneventful youth in which I served
I had it all: a true blue girl
an art factory in the San Francisco Mission
a little red Volkswagen bus
in which we toured as lovers.
I painted and lived off a small legacy.
When that ran out I searched the want ads.

With a sense of dark humor I tried selling door to door
for a line of vacuum cleaners, the Fairfax to be exact.
A team of fledgling salesmen fanned out
across the Haight, Fillmore, Western Addition,
and the Mission: all cold calls. The training sessions

were led by a black-bearded giant.
He disparaged the obsolete model
the housewife would be likely to abandon
for our new machine—and for drama
he waved the monster around in the air
in wide arcs, with one straight arm, calling it "dirt."

Ashamed of my new status I left the factory
those mornings by climbing out a window
dressed in a suit and tie, with the gleaming machine
and its accessories at heel—an obedient mascot.
It was a wide territory, difficult often
to smile as I rang the doorbells of strangers
but I improved by increments.

My first strike was an old bachelor in a
basement apartment on Pell Street
which he shared with his shaggy white dog.
The pet's fur blanketed the floor.
When he saw swaths of his red rug reappear
he signed on the spot.

The next was a Filipino widow in a walk-up flat
behind Market Street, a place of immaculate
linoleum floors, wooden backstairs

and about a dozen children. She invited me
to a dinner of pig blood pudding shared with her brood
and another guest—an insurance man—
trying to sell a death benefit.
I bought his policy for a $10 premium to be nice.
Sadly, her machine would be repossessed.

I once rang the bell of a man about 40
who happened to be home alone
glad of a visit—contentedly doing nothing
maybe living on a pension
from the Merchant Marines.
He had blond curly hair
faded past youth, blue eyes, a squat chubby frame
but agile and quick, hands with a relaxed curl
like a cat. He nakedly ignored my demonstration
of the chrome-plated monster.
He wanted to talk about ship-building.
My favorite customer.
No sale, but I saw a ray of hope.

THE WISHING POLE

We climb The Pole
emblazoned at the foot
like the love-tree's trunk
with signatures and soot
then upward notice
a spray of sloppy gray
wrought by seasons on its hulls
a test of birds and rust.

It is a swaying tower like Jack's
sprouted in a fearful dark. At first I dread it.
Climb the cold steel rungs and count each one,
89, and bring a paper bag
with lunch and juice for noon
up in a cadence of a swim.

Meanwhile a manic derrick with a claw
grips dead cars made light as straw.
I see one dangle then drop
into the monster's maw,
which belches out a livid crop
of feral chaff. The giant's gut sometimes erupts
a puff of flame shoots from its mouth
emits a crack and boom as rude as hell.

As we start our work the streets recede
teeming with drab mysteries
a muffled sound, a fog beneath
the outskirt's tide of lulls and swells
we work in a secluded parody.

Any handsome madman theme emerges
with a splash. We use oil like mechanic's grease—
the advertiser's season with a laugh—numb brain
and muscles working toward a fair repay.

We belong up there, happy misfits:
to glorify the car, the quenching drink,
the bathing lass, the bat device,
a glass with rum and ice.

And yes, the novelty wears off
we mostly focus on our feet
for stubborn goats a rocky slope
on rusted iron fire escapes
warped walkways sometimes fixed
with bailing wire, forgiven with neglect.
Our mission is to pacify and win
the hugeness of it all, get paid, get home again.

But I'm sugarcoating now
wishing back on youth. Might as well
keep wishing back to East St. Louis,
Illinois and that racetrack in '66
my under-20 reflex like a colt—
just get out of town, I had an urge to bolt.

We drove to an empty track
I jogged a quiet furlong by myself
while tomboy Tina waited by the car.
The track was hers, in her family,
we drove there on some chore,
not a date, just to talk
or steal a kiss I'd hoped
there were no horses—all boarded out.

The clods were dry and chunky underfoot
and in my showoff run
we both burned off excessive noon.
A boy's wild oats were not for her.

The blood pounded in my ears
beneath the throbbing sun—my life
had started with a bang. Those were glory days
as well, and the empty grandstands sang.

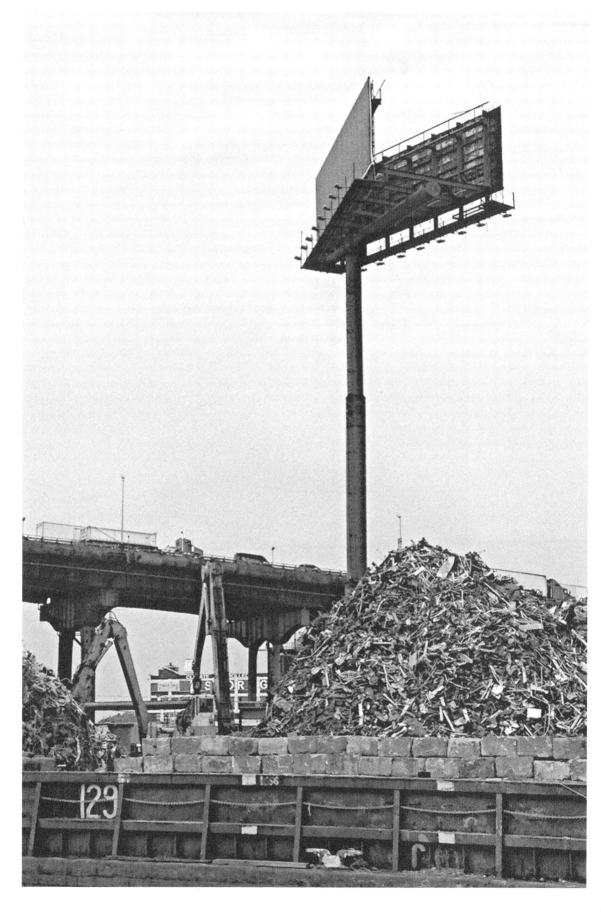

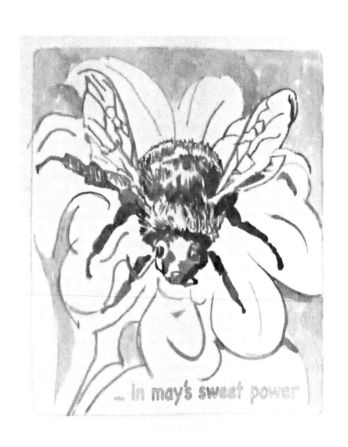

... in may's sweet power

JUST WED

Climb the steps of this Grand Hotel
New York (1907) citadel, imagine it new
as the city's thriving power
swells and drives in upward size
and upon the cobbled streets
the burly men and iron-shod feet
of warm blood horse makes one obedient beast.
Jackhammers weave their tattoo
of determined noise
beat a towering urge to rise.

Down here you'd need a farmer's nose.
Ladies in pairs or solo
thread through the mob
boom or bust sport parasols
ranked according to their means
in multiple and daring serge
they stormed the bastions of the world
in flowery bonnets, tailor-mades, nosegays
castles in the air for their repose.

That grand old dame in her historic bower
locks in her heart the wedding hour
when bride's new blood thrashed in her ears
swore faith upon love's valiant chores
with her new man whom she'd just made
so thoroughly hers. Just wed
he held her and their fortune firm
enjoyed in May's sweet power
when the brute bumble bee
tours from flower to flower.

MUSE

Nude-struck in sculpture class
excitement in my pants, the wire frame
buried below the slippery clay
pricked my thumb like a fish hook
as my fingers slid in wild abandon
to tweak and copy her lithe form
standing in broad daylight among the classmates
she before us naked young
in all her loveliness.

My yelp of pain clowned, brought laughs
broke the puritan ice,
proof to the German prof
I'm such an amateur.
When asked a point about his German youth
he drew a line: *"I'm not here to make confessions."*
He had uncanny skill in craft
a master of the handsome dog in bronze
dignified graveyard monuments.

The model was an actress and fearless.
I wanted her privately
her form as muse.
Life is not so messy, the art
of mopping floors, the convenience
of flush toilets, the awakening
from an unruly dream
to a day of efforts and possible golf
friends who pass through in orbits

but I remain steadfast
sustained by canyons past
and the upright wonders
of Yosemite, summers
of outdoor vigor and lobster
on Cape Cod, clean sailing in Maine
and now settled in the shadow
of Green-Wood Cemetery
in a Brooklyn village
I seek consul from my betters
who reasoned with their discontent.

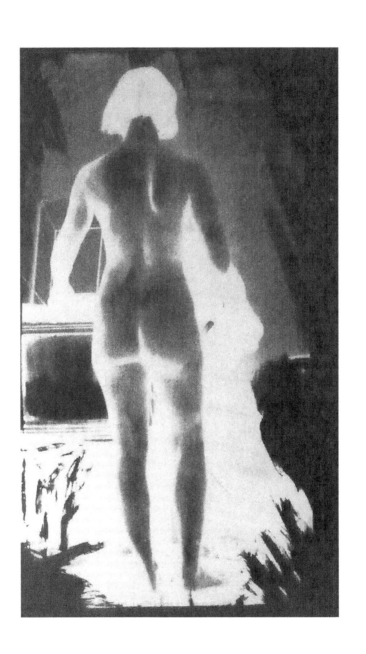

WALK DON'T WALK

JR had a cadre of strong men, all specialists in their trades. There was Jones, the music mentor, who was trying to lead his friend to a higher ground on the saxophone. Jones was a self-taught composer, and lived conveniently next door in a high rise apartment facing the Hudson. King Jones and his family enjoyed the sunset from their castle on the thirty-ninth floor and JR could come by any time with just a phone call. Jones would leave the door unlatched, the sound of piano tinkling and beckoning through the crack and down the hall. After some warm-up riffs they would toast each other with a glass of wine, and JR always brought something.

Painting and music were not just hobbies. He had always painted and sometimes wrote sad and funny poetry. He came to New York to "make it" but it was slow going.

There was Big Al, the mayor of West Broadway. Usually clad in paint-splotched bib overalls, always the glad-hander. You could buy a lid of grass from him or hang out and drink beer with him in the basement on Sullivan where he was the super of a few buildings. Always the same low-key generosity, telling the same stories about the characters that amazed and tormented him, each time with a different flourish if you had the time and ear.

Al would chide JR who, in spite of his job painting signs, was an educated bohemian dude: "JR, sometimes you do dumb, redneck things . . ." Al was the king of redneck. He played guitar and wrote crazy lyrical songs of his days in Florida before coming to New York.

Life was smooth downtown, and JR had lots of pals in the many bars. At work there was Spike, his mate in the dizzy world of outdoor signs. A Puerto Rican bull

who looked out for JR on the job and off. They met in the Apex shop and worked the boards and structures high above Broadway's Times Square. It was a dying empire but it didn't want to die.

JR had defaulted into that world of novelty and numbing vertigo after a hit-and-miss attempt to feed an art career. Long hours in the heat and cold, dangling over the streets with brushes and buckets led to a rough brotherhood with Spike, and JR heard all his stories. Spike saw the angles and he knew how to cover his tracks. He could commit impressive thefts but left no clues. He was always the same alpha dog from old Orchard Street, but also a young family man. He knew the Apex routine but demanded respect. He could sulk and a hot temper could flare up. He came back to the scaffold in a bad mood one spring day after lunch. He had gone to the park to cop a nickel bag, just to take the edge off. He was angry about something.

"Today I could stab someone, sit down nice and calm and finish my lunch."

Guido was JR's tightest buddy but an enigma. They had met at the Apex shop, both distracted and talented artists coping with the lockdown world of organized labor. To these two new friends, Apex was an inconvenient joke. It was an overlap between art and a novelty world where images were blown up in size and glamorized by an invisible artist swinging on ropes like a Houdini trick high above the streets. It might be a big Gotham comic book story to his arty friends but it was grotesque if you had to live it day by day.

Guido had brought a keen ambition and sense of himself to New York from Italy—and the art world was his main target. By contrast, JR was modest, often befuddled, and could easily find himself in the shadow of his colorful friend. The two would drink and argue, like Castorp and Settembrini in *The Magic Mountain*. Guido was reading Nietzsche and was impressed by a mind that broke out of the frame, cut through the bullshit. If JR could only see reality, Nietzsche could unlock their next move. "Stop wasting your life working in the shop, tied to the apron strings . . ."

Other artists they knew had broken free, created audiences, and started to *make tons of money*. "When are you going to get serious and start working with me?" Guido would ask, as the two confronted each other in the street after beers, before going home to their wives.

Like some young men of smoldering ambition, JR had a chip on his shoulder. He would see the moment when he should have plunged forward with his art, but then held back, hesitated. He would show up at events to congratulate successful painters only to feel like he worked in the post office. His mentor, the great Alex, even joked that he did.

He snapped in arguments with his wife and on occasion punched the wall. Or that time he punched a hole in the bathroom door of a motel room when a girlfriend changed her mind and wanted to leave as soon as she entered its spare chill. His hand bled. He iced his bloody fist with a wet towel, deeply embarrassed—then she relented and dropped her shoes. He did it again teaching school in his

previous life. A kid said something direct and personal that touched the third rail. He lost his temper, punched the wall near the kid's face, and broke a bone in his hand. That stunt cost him the job, but he soon tried another career in Youth Services when the city was desperate for staff. The kids were wild but basically okay. A few would always dare to get in his face. They looked for his weak spot and sometimes JR lost his adult advantage. You couldn't curse or touch the kids no matter what. They would know then they had won. This was in the era of Bruce Lee. Ghetto kids fed on fantasies of the Hong Kong master and mimicked Lee's deadly falsetto croon.

Then there was the career of Ali. JR tried to watch all of Ali's fights in pay-per-view venues, and studied the newsreels after. Any fool could see that Ali had the advantage of a fast and devastating left jab, a longer reach than anyone. He could toy with his opponents and force them into desperate errors. JR practiced keeping shadows at bay for imaginary fights to come. If you had the long reach, fights were easy. Just like Ali.

He hadn't actually been in any fights. But he was lean and wiry—bored and frustrated by his job at Apex, and haunted by an old fear of schoolyard bullies he had run away from. His job of hauling on ropes was physical and that gave tone to his long arms and strong back. Frustration sometimes drove him wild. He could punch holes in a sheetrock wall if he could only miss the studs. The skin on the knuckles might break or be sore for a few days, but that felt better than the explosive pressure that sometimes built up and blindsided him.

Sometimes he was angry at Guido. The two were dynamic, no doubt about it. They could team up on a scaffold and break speed records painting the amazing murals that Guido dreamed up and promoted for himself on city walls. Or JR found clients with commercial walls on Canal Street and around town to earn a few bucks hanging up in the air, no questions asked about insurance.

But it was tough to get Guido to show up early in the morning and not hungover from his exploding nightlife. One time, JR had landed a job but they didn't get it together to start painting until the sun was setting. An argument flared up on the roof, and the two squared off to rumble like strangers. Just then JR's beeper went off. His wife was in her ninth month of pregnancy and JR had no change for the payphone. Guido smiled and fished out his last buck. JR came back to the roof with the news that she was testing the new beeper just in case it was the real thing. The two then melted back into friendship and wrapped up for the day.

* * *

One Friday night they were relaxing at Barbara's. She sat in a kimono applying cold cream in her mirror. Barbara was an art dealer who showed Guido's work in her Soho gallery. The two had been drinking more than usual, but were in the groove. Guido sat in a barber chair sipping a Heineken, ragging JR about the Jews.

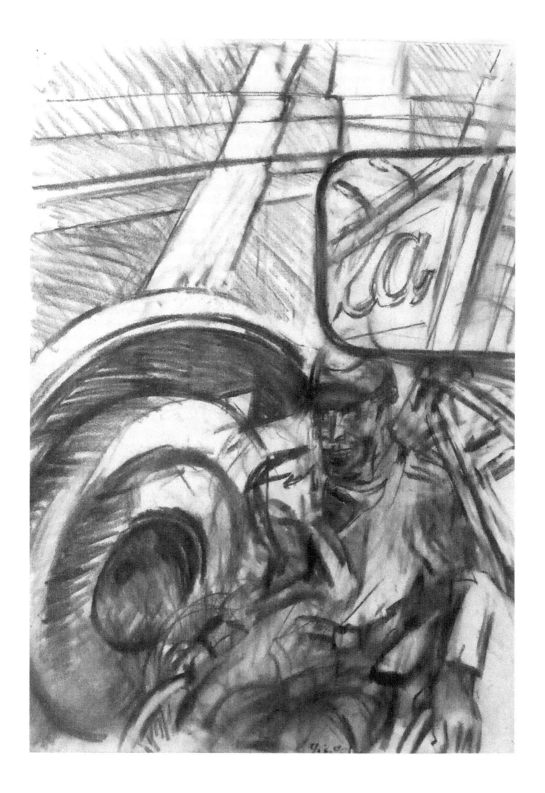

This was a sore subject since JR came from Yid stock. "The thing about the Jews is they get down to the level of a beautician."

"A what?" said JR truly dumbfounded. "Explain that. And what about your Jesus and the virgin birth, the malarkey about the Son . . ."

"I mean the circumcision, down to that level . . ." Guido was proud of his foreskin and why not? It was attached to the equipment he was born with and used daily—not just to piss through. The delicate form is detailed on the statues of ancient Greek gods and Roman athletes in museums for all to see. And in the Jewish religion, there were no graven images allowed, showing round mushroom-shaped cocks or not. Art was gentile.

Guido was a prima donna, but he had the upper hand with bullshit. JR was impressed by his friend, his ease with young women, his connections in the burgeoning world of art and fashion. Fame seemed within grasp for him. So what's all the fuss? JR remained passive and mystified. They could get on so well, then some dumb argument would arise.

It was spring, there was something new in the air. Why not concede for a minute that the dreams that Guido was always talking about were showing signs of appearing on the horizon? They could hope.

"Let's go to the Blue Light," Guido said, changing the subject. It was only ten o'clock, still early, on a Friday and no work tomorrow. It was a night of the full moon and anything could happen.

The Blue Light was an after-hours club in a defrocked church on Sixth Avenue, and all the doormen knew Guido. Even dressed in paint-stained jeans he always jumped to the front of the queue behind the red velvet ropes. Guido was also a star decorator in the clubs, a friend of the owners. Once inside they would cruise the dance floors, stopping to greet friends—gaily costumed kids who seemed to live only for the frenzied energy.

JR felt like Dante following Virgil, led through the stages of the afterlife by an expert guide and interpreter. Guido knew everyone. There was his flamboyant and handsome friend John Bone, who performed oddly chaste vignettes with a big platinum bouffant and a handsome python wrapped around his classic white torso in the club's spotlight. They looked for Nick, the tall coke dealer, and gave him a sly nod. The transaction was a swift and invisible handshake. A little bump of coke was just the ticket for getting through the night after a long day. Everyone in the VIP lounge was doing it. And it was impressive to sit down at a table with the polite and mysterious Andy. How did he have the stamina to stay out at clubs and parties every night? How did Guido get to be on such good terms with him? At the tables in the deep recess Andy might grant an audience—presiding with a calm deadpan chic, his encounters reported in the morning's daily press. Andy's wan stare would drift over the crowd and scan for celebrities. Maybe things were going to work out after all.

JR was known as a silent partner in these club outings, a straight man, not knowing whether to mingle or slip off on his own. He felt defensive, but what was there left to defend? Innocence? After his trial by fire of a decade in New York, climbing over walls and out windows at Apex, he felt ready for almost anything. And the tawdry neighborhood of the Forty-Second Street studio nestled among the peep shows they sometimes shared was a cynic's paradise. He reminded himself that he had a family to defend, and yes, some innocence.

Every turn in the crowded club was a crossroads for JR. The throbbing music from the DJ hurt his head. On the other hand, the air of celebration was spontaneous and real. It might be lucky this night to stay near his Italian friend. It looked so easy to kiss friends you haven't seen in a while. Or kiss complete strangers if they were in the mood. And where else on the planet could people afford to be so outrageous? Didn't anyone go to work in the morning?

JR even got carried away on the dance floor, dancing near three six-foot-tall black women in shiny gold shoes and party dresses. But they weren't really women after all. And he was only dancing near them, not with them, until they made insinuating remarks that stung and embarrassed. But it was a fun night anyway, and about 2 a.m. in a show of courtesy he conferred, lips to ear above the din, with Guido for a walk home together downtown.

It was a nice night for a walk. JR wore a new spring outfit: a blue pastel shirt that matched soft Miami-style slacks. He was tired of paint-spotted jeans and those medieval-looking hooded sweatshirts. He was in a gay mood, until Guido rubbed him the wrong way again. How JR was wasting his life, a servant for the bosses. How the artists should rebel, go on strike, and leave Apex and the union helpless. How JR was sacrificing himself—and Nietzsche again. "Why do you always do the most obvious thing? You are looking in the wrong place." And didn't he know he was dancing with those transsexuals—so don't be so Anglo Saxon and stuck up!

JR was a shade taller than Guido, so strolling down LaGuardia Place, he had to stoop to catch the argument above the noise of traffic. It might look to a casual observer that they were having a lover's tiff. For JR it was tense, tedious. It was the same issue over and over again. His defenses were up: *He's just using me as a convenience. I'm recruited to help him move ahead then he'll dump me like the dumb-ass sign painter he thinks I am . . .*

Crossing Bleecker JR saw an old nemesis in the form of the crosswalk sign— alternating randomly between the words WALK and DON'T WALK. He pondered the irony of this message and what it meant in his present mood when he heard a shout, miles away from their argument, but jarring and ugly: "Faggot!" It was a ragged male voice, like a heckler in the bleachers of a Mets game. Faggot? Who's yelling this shit?

The call of "faggot" came from the blur of a sinister car, forged in the rounded lines of the fifties. Could it be a Hudson hot rod? Maybe there will be a point to all

this confusion, hesitation and argument. A half-baked hope flashed—but also a hint of menace: "WHAT!?" he shouted back to the night sky. In the parlance of bullies and schoolyard toughs his words were not flung upon empty ears. He had just notified an enemy that he was taking their challenge.

Looking up from the crosswalk JR did a doubletake. The owners of the joint on the corner had chosen Walk Don't Walk as their business name. *That's cute*, he thought. It was late but there was a lively crowd on the sidewalk, but no patrons sat behind the knee wall where the daytime café tables served burgers and beers.

Arm in arm the two tall comrades looked up from their discourse on Nietzsche to see the sinister car of retro vintage stop at a resolute angle in the intersection. The two front doors swung open as if it were the scene of an accident. A horrible black-bearded man leered at them from the passenger side with candid enjoyment. Were they selected for starring roles in a scene? It was unfolding with a delicious slowness.

* * *

The black-bearded man stepped out of the car, showing full white teeth by way of a greeting. A shorter man with a dirty blond mop tied in a bandanna came around from the driver's side, wearing his courage with a compact nonchalance. There was something else about the short one. They couldn't quite place it but it was next to evil. The year was 1986 and the intruders were dressed something like pirates, vests with conspicuous metal chains, insignia, and buckles—long hair clamped down with a strap across the brow, fearless and ready to do ugly things.

JR kept himself in passive mode. He later regretted he hadn't made a choice either to stare at the plate number of the car and memorize it, or just keep walking. Instead he focused on the dumb signs for the restaurant, the stoplight, and the soft, cool night sky. Maybe he had the sign disease. "Walk, Don't Walk," he muttered to himself. He painted signs, forgot to read them, but they had a power to influence in hidden ways. Also, his gorge rose in anger with what Guido was saying and then this *faggot* insult. It was too much.

The fight itself was over in a flash. The four men at first settled in for a casual preliminary chat at the café railing. Guido tried to moderate. JR sat on the rail, enjoying the absurdity of it all. It might look like to an impartial observer like the painting of Jesus in the peasant hut by Caravaggio: biblical men with sweeping gestures, gaping mouths, full beards, and long hair. The mood, which had begun like a hippie protest, was turning sour.

"You walked right in front of my car," said the stocky short man, for openers.

"Your car . . ." JR slurred in drunken mockery, looking at the hot rod for effect. "Anyway, we had the light. It was green." The two buccaneers grinned in disagreement. "In California, the pedestrian has the right of way," JR added as a non sequitur.

The smaller man seized the advantage: "But we're not *in California*." Temperatures were rising. California was where Charles Manson was languishing in prison. California was relevant. The pedestrian was king. In a sneaky way JR was trying to size them up: *"Definitely trailer trash, and what's with the buckles, tattoos, and headbands? This guy's a Charles Manson wannabe, looking for a fight . . . with Guido at my back we can take them."* A notion of this kind took its vague shape.

By then two girls, similarly clad in beaded vests, headbands, jeans, and boots emerged from the back seat, where they had been left waiting in the roomy interior. They joined the small circle, glaring at the two artists with cold, disdainful eyes. The coupe was still in the same spot, in the intersection at a rude angle. Cars and taxis veered around it. There were no cop cars or patrolmen on foot for miles around. Heavy metal music trailed from the open doors, stalled like a prop in the intersection.

With the arrival of the girls, JR could not help but see the startling resemblance of the short man to Charles Manson and his family. Before he could think, the words were out: "Who are these girls, *your children?*" They did look like kids, but the age difference between them and their escorts was not that remarkable. It was the kind of heedless wisecrack JR was known for, and a mistake. He and the Charles-guy traded insults in a locked gaze. One of the girls came closer, scenting blood. The two gay-bashers stealthily arranged their footing while Guido was still trying to smooth things over.

"Aren't you going to move your car?" asked JR still sitting on the fence with mock interest, pointing casually at the Hudson with his extended index finger.

The girl nearest to him slapped at his hand: "Don't you know it's not polite to point?"

With her slap the moment ignited. The big man with the beard leaned in close and almost whispered: "You want a taste of him?" to either opponent, like a leering referee. The appetizer of insult had finished and the main course of violence was now served. JR was already on his feet, setting himself for a long left hook. Diplomacy was over.

JR would later describe the incident as self defense: he threw the first punch, his best shot, a straight left from the shoulder with an upward twist into shorty's nostrils, with all his drunken power. The blow had little effect. There were no front teeth or cartilage breaking under JR's knuckles, no nose bone or sensitive tissues rearranged to befuddle his opponent's nerve center. Those had been damaged and lost in a hundred fights before.

The shorter fighter knew his ground. The Manson dude hugged JR by the knees and dumped him like a sack on the sidewalk. Foot traffic casually resumed around the inconvenience. The night crowd went about their business as usual.

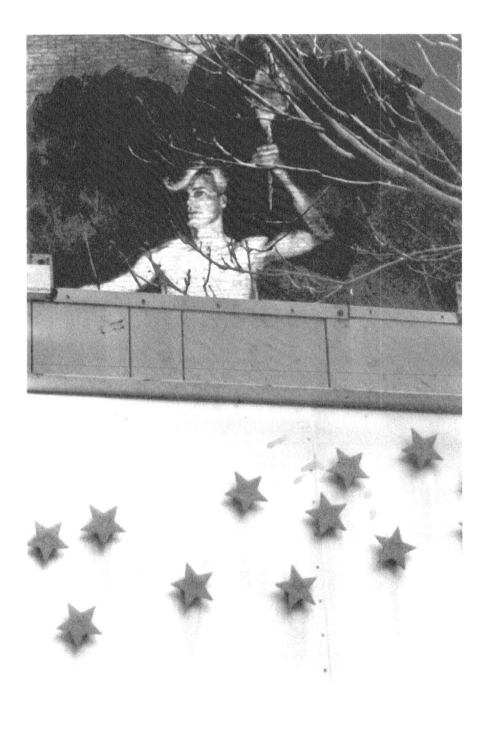

As the two wrestled for position, JR scraped skin off an elbow and a knee, tearing through the soft cloth of his new outfit. He was perhaps the stronger, and it was going his way until . . .

Looking for Guido and some help in the fight he saw the punch from blackbeard land on his partner's cheek. In a blur he registered his friend's retreat: *"I'm going to make a phone call . . ."* From the ground he saw Guido hurry disgustedly into the restaurant. This tactic left the tall man free to casually kick JR on the pate with the toe of his boot. It seems this boot was fitted with a metal plate— protruding, just enough to cut to bone. A fresh scalp wound began to gush, just as one of the girls sat on his chest and tried with determination to get her fingernails into a bare eyeball.

The moment went dark in JR's eyes. The eyes under attack remained shut tight. In that instant he knew his hesitation had been a grave error. He had chosen DON'T WALK instead of WALK, and now found himself in a love-battle with fiends from Hackensack. Guido was right. This had nothing to do with them, with art, with ambition, with money, with loving beautiful women. Choose WALK and life is beautiful. He and Guido would finish the strolling argument the same way they always did. They would agree to help each other in the fight to get to the top, try to make a few bucks, stay alive in that spirit that makes good art, buy each other another beer . . .

As in those legendary tales when adrenaline and muscle team up to save a life, JR sat up, moving against those heavy bodies which oppressed and harmed. Like Lazarus from the dead, he felt himself sitting up with a righteous and liberating power. In a moment of blind faith he tipped the balance of resistance needed to be free. Against all odds he got to his feet. The four tormentors tried to hold their prey by the shirt, a rag that soon flapped empty in their hands like a flag of surrender. JR had slipped out of his shirt like a diving duck into deep water, and was next seen streaking east on Bleecker Street.

Still in a panic he cut through the alley behind the Grand Union, behind David Davis Art Supplies, toward the green lawns of the University high-rises. Blind from rage and fear his legs kept going until they caught the sidewalk courtesy chain that scythed him down onto the soft dark grass. There were no pursuers. He was safe. Then he vomited from the emotional mess, a cold sweat on his half-naked body. Guido soon arrived with his torn shirt and helped him up.

Back on the corner, the raiding party got back in their car, the sturdy wrestler now clamping his head with both hands, as if shaking off a migraine. He stroked his spiky mop, muttering and cursing, "Faggots!" They drove away.

Not much was said between JR and Guido as they walked shaken through Soho. They found an all-night deli where a deadpan Korean man let JR rinse his bloody head with a garden hose kept handily out front to dampen flowers and freshen the sidewalk. They shared a taxi to Greenwich Street. As JR stood to enter

the loft where his family lay sleeping, he smiled to his friend, who after all hadn't asked for this fight and didn't abandon him entirely. Laughing out loud at himself, at the stupidity of it, he wondered how the night could still be beautiful. He knew that Guido would always be Guido. Nothing terrible had happened. He would know what to do next time. He would not have to do this again.

The next day's hangover was rough. Guido came over to the studio on Ludlow, to follow up the plans for getting ahead in the art world.

The two were chosen to appear in a big survey show of portraits at a new outskirts museum. JR would get two pieces in the show and would probably attend the opening with his wife and kids. Guido would show a daring nude portrait of a prominent art-dealing dame and greet his famous friends. Nobody could paint like Guido.

JR worried that he was going to look a mess at the show, with the cut and scratches on his eye, but maybe that Afghan army hat from Canal Surplus would be the right touch. His own work was good but he had lingering doubts. Would it go over? Would people like him?

Guido was annoyed by the excess of the previous night. "You know, we aren't really fighters," he said, a little shamefaced but making the point. Then: "Can I use your phone?" He picked up the receiver of the heavy desk phone with the spiral curlicue wire. "I want to call someone successful," he said with a delicate courtesy. "I want to call Andy."

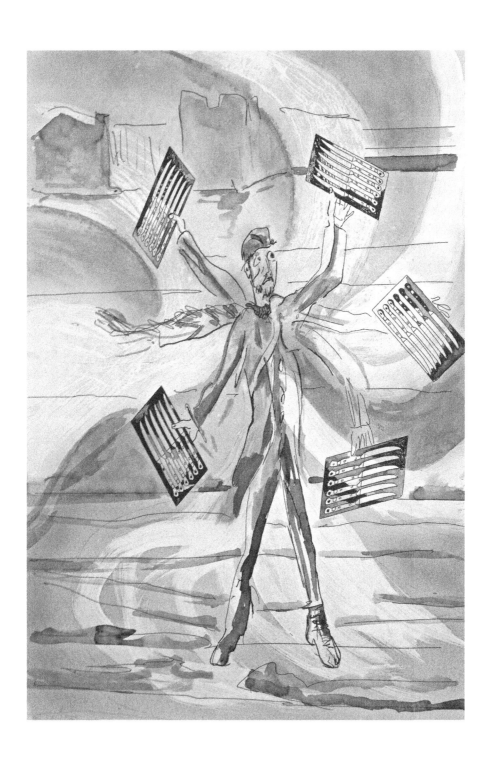

I AM A STREET FRAMED IN A WINDOW

Artistic and restless, I stand in the window
to eat pasta, to practice alto sax (Jorge
our fifth-floor diplomat—newly posted to Geneva
flagged me on the stairs last night for one last
nightcap at his late United Nations bash:
John, get your sax! This morning's hangover

framed in the high window I await result
straw smoke black or white, a new namesake Pope.
Out there the Hudson in its tidal churn
sweeps across to the Jersey City skyline.
Further up the highway
gables of tall houses wink sunlight
from the Palisades' top shelf, the Hoboken cliffs
somber remnant of Earth's big youth.
They stand sentry to Manhattan
while down in front, a merry flood on wheels
cuts lines through the white snow's crust
in lashes of black macadam. The artist that I am
sees a winter carnival by Breughel:
dogs paired in love to owners, lean silhouettes
strain and prance against the leash, led by agile men
in floppy boots. A knife vendor with windmill arms
stands against the gale to catch a sale
my window is the camera, warm room my brain.

Our son is sick, puffed and angry in fever.
He will grow an inch today. *Go to your mum* I tell him:
sleep with her, avoid as long as possible the world of fathers.

On TV the Olympic figure skaters
dedicate their scrolls in Swedish ice, grace of hands
and urgent legs open outward, yearning
supplicate for their reward—gold, silver, bronze—
they skid to a breathless close. Desire now
rests complete, awaits the score.

I am a street framed in a window
content to love, enduring eternity of Sundays
books unread in friendly piles.
The Man with the Golden Arm
promises a handsome vertigo—the cover art
portrays a good man—his mettle put to proof
clad in the upright gray flannel suit
but plunging head down from a roof.

I join the villagers in a small grace
toss pennies into the fountain
of my charmed life
while today's mail demands thousands.
I watch the river's glassy face.

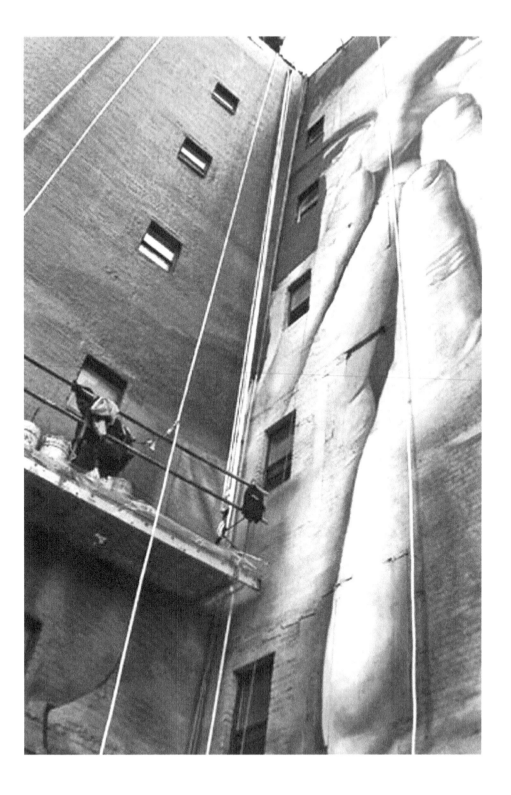

VERTIGO

One white cold morning I had a sweet fright.
We four sign painters in a red Ford truck
our shoulders swelled by winter coats
drove over the Queens Bridge
grand panorama, our daily joke a wag would ask
if that random man pedestrian
had had enough, end it all and jump.
So these three bozos and myself
were jammed together on the bench up front
against the windscreen in a bunch, laughing
ladders rattling, the morning rush, and traffic stopped!
And in the bright cold day I cracked the door
in an urge to walk away, impatient, honest.
I swung it open, touched my boot
to the trembling grid, could see the river churning
through the steel, East River's deadly undertow
snow-covered floes busy killing any hope
except for fish, a skimming gull, I alone
in the standstill of the throbbing road.

The smokestacks shot a sash of white
across heaven's hard blue dome.
A battlefield of boisterous clouds
contested home, the wind skirmished
in the cables, sang an anthem.
Flagpoles battened their stiff flags In Excelsior,
a glory and fanfare decked out for the last Day
a hymn for when all Saints roll in.

I thought I'd walk a pace ahead
careful not to crowd the rail or spook
a wayward look, on a quick and easy stroll
thrilled by big danger down below
beard the tiger in his den, have a tiny look-see in.
Some unrepentant rage in all this power: the humming
bridge, the attitude to enter from afar
almost descending from the air, another sphere.
I stood in air and marveled at it all
got back inside we rolled along.

No one paid us any mind, a work truck and a grandpa salt
at the wheel, a dry stogie in his toothless mouth
all grinning, that old maverick and us.
I wanted to get out and test my legs is all
and see the whole, the world in scale
not morbid or maybe just a bit like now
a nanosecond such thoughts allow.

THE POET WE ARE MISSING

In the dream a scissors cuts invisible scraps
from the goods. What *is* the material?
My body clock works back
tossing by my mate until her sleep
is nicely cooked. Mine simmers
back again to New Haven, the snores come
to a glorious starry night
a full moon in the dark alley garden
(in June) at the end of school.

In the hunger of that moon
I squeeze the narrow bones
of an overwrought girl (Laura)
in French and Classics but her moan
is too black and gaseous
so we hurry back inside to kill
anything left of the romantic.

She does not eat well or take care
of her slight and too bright self.
Later I would call an expensive ambulance for her
when the floor walking failed. She made it, false alarm!
At her Christmas party I place a poem on her tree
folded lengthwise resting among ornaments
near the tip, flax, and angel.

I was full of piss not yet precise
and impressed with so many brilliant
jaded men—painters, poets, and critics—
famous men who made their mark
along the college circuits and the bird-bright
Hampton hedges, who held hard-won views
in counterpoint to Marx, I wanted to pretend I knew
how to be like them, especially Stanley
the way he spoke, conveyed his thoughts
stooped in concentration, his hair erect in spikes
trimmed by the gardener's shear, dark
horn-rimmed specs, English tweeds,
suave rhetoric—a rueful flair.

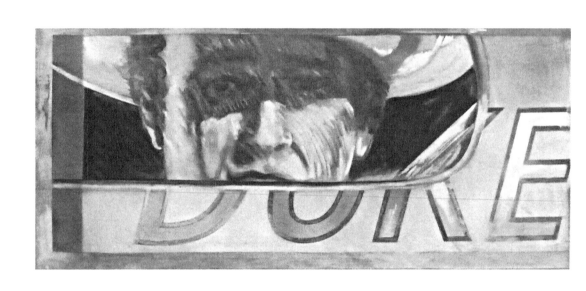

But I'm stretching memory back
to New Haven and visiting intellectuals
and that private zone
where I'd dare to try my own:

Time is the escort at your elbow
when the matinee ends.
It pulses in your little brother's hand
held in the exit's regimen
when dreamers rise and stretch, the credits roll
after John Wayne had pacified the land.

The doors that held back light
unfurl onto Main Street—a tapestry
where cars, bus wheels, trash, and atoms bright
succeed and tumble, a din and constant elegy

then you'd blink,
read the signs and not pretend
remember the way
to lead us home again.

A SHORT STRETCH

(for Brian)

Visitors in prisons laughing
(MGM Leo roars in the preamble)

Would I be here if I sold you out?

Pal, I see you settle in behind the glass
wearing the scrubbed white T-shirt
tensing your new uniform of muscle
frightened and unhappy. Your soul was cold
deprived of touch except the kind
no one wants, the wielded chair of self-defense.

Time before we touched easily brother
drank from paper cups
watched from the penthouse
the Shriner's show below,
midget cars swerving in the street
the doctors urged more clowns,
healing with charity for the sick kids
wearing red fezzes funny and reeling.

You dumb yid! Why'd you delve?
Associate with dreck? This was in June
some time before 1980
when the Men's House was on West Street.

I spoke to you over the black phones
the long distance call we mimicked
our fingers match printing through a pane of glass
your frightened girlfriend leaking ballpoint ink
on the lawyer's couch—he got you into
Danbury, a short hitch—where you could jog
keep fit, no fights, no punks. I got you Jerry
the artist's lawyer. In five months you got out.

* * *

Brave were we, the motorcycle rides up to West Rock
expressed in that tattoo, that said something in Persian
that woodstove in your studio, in Soho
the logs on the chopping block
something sweet and mystifying
opaque, like Nietzsche, Jesus, Nijinsky
then you went to Bali, smoked some kif
went in for the night swim, not like
the undertow in Lake Michigan, something darker
like murder. They found you on the beach
naked with that tattoo. You were a pretty corpse.

I got the news in a heat wave
working on Brighton Beach
painting a dragon for a Chinese bank.
I spent a week or two in orbit from the shop
not painting, not going up
with Rico looking out for me
calling Joe from the payphones
dipping in the waves up to my knees
drinking vodka with Russians on the boardwalk.
It was a mess, some tears I guess.
Your soul was cold and needed touch.

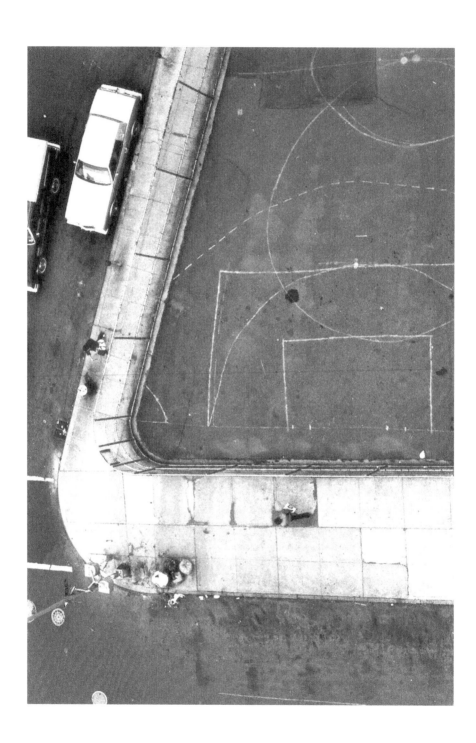

HERO

Opinions from schooldays failed
when the argument got out of hand
hot words, quick fists, curly locks in your face
the upright of gravity capsizing like a ship
then rolling grappled for supremacy
blood pounding in your ears, seeing red.

Picasso took Braque's dare with boxing gloves
until one punch landed on his nose.
And that was that. The match was off.

My childhood hero was Ken,
curly blond older brother
to my pal Dickey, the dark one.
When words brought fury
the little bastard fought.
They were both inventive
using anything, wire whips
with square nuts tied on like cat-o'-nine
popcorn kernels hot from the pan
poured into pajamas, anything.

Mrs. A resorted to the cops
to stop them more than once.
They wouldn't listen.
There was always a windup speech
before these duels but not after.
It would always end in tears
a run for cover. The hospitality
in the backyard put asunder, the little mob
dispersed with downcast grins
some shame at last.

We were all cowards but interested
in fighting, and these boys
could show real souvenirs from Germany—
(from an uncle in the Marines)
a nasty looking Luger, a US .45 automatic—
both replicas cast in lead
(hid in the deep freeze
Dickey got his tongue stuck to it
experimenting with the cold)
flip-knives and greasy bayonets
displayed with ceremony
on a green backyard terrace.

It was the postwar buzz then Korea
domestic pride in World War II
the Saturday matinee forces on the screen
in black and white—John Wayne
swords merged with faith
crusader shields for children.

But even now I wait at leisure for a hero
to come along. He must be handy, calm
like Ken, a handsome lug
a sailor, a plumber, a bartender,
or an attendant pumping gas. I see him now:

He stands on sturdy peasant legs, good calves
the wind playing hell across the deck
or in a blazing sea high in the crow's nest
then plunges down into the dusty dark
to start a silent film
in the spotlight of a vaudeville stage.
He points with antic care
to captions on an easel
words on show cards, without sounds
that piques our smile—fair curls, blue eyes
himself not innocent but blameless—
the curtain rises then he doffs his cap and bounds.

HUNTING WITH GUIDO

Worry about nothing, words frozen like wax
melted from the candle's stub
jelled upon the bottleneck's chianti straw
a sparse country tabletop
greasy oilcloth, flaming maples
wind rattling leaves, twigs scratching glass
the warm wine swilled easy
before the winter's lock and trap

It was like that but darker.
Schooled by the safety class
he knew the culling seasons
of deer and wildfowl that week
all were off limits except the crow
whom we loved and let go

That 10-gauge to shoot the wild turkey in December
I understood, was for Christmas with his son
and that misery in the rain without a dog.
He quizzed me endlessly
about a script with homicide
that we would make up as we drove along
(with the licensed shotgun by his side)

Or when he came to town
we would look for trouble near the Arthur Kill
past the Oz of refinery towers lit up in lights
looking for a go-go: The Saloon.
I laughed when he annoyed a naked dancer
by offering her dollar bills back-asswards
high up her leg. He even fed
a tip in worthless lire

so that sudden slap like a pistol shot
he got—we both deserved
with our neon glow grins pasted on our teeth
in the black phosphorescent light
having a good time behaving badly, but attracting eyes
of local hicks—mean and twisted
one slipped a black death-threat pamphlet
into my anorak while the bear of a bouncer drooled
for a taste of us, so we were lucky
to get clear—and *we* were also hick.

There was a clearing in the trees,
on state park grounds near Roscoe
where we shared a picnic of provisions,
hot tea from a thermos, a sandwich. The snow
was a crunchy white, the sky rang truly blue.
We set up a target—backstopped safe we hoped
to anyone downrange—fired off a round or two
against an oak. We were friends
this was a bond, illegal and a joke.

INVITATION TO THE COCKPIT

The gentle lay of our mission is west
cloistered in a hard bed
dilating the throat for salt gargle and song
yellow cat's eyes wide as saucers.
The amateur weds to paper, daubs in paint,
pickles bronze, and sculpts the flower in stone—
of our friends and loves make legend.
On first glance of you betrothed

your wedding picture by mail
in Amsterdam, a Catholic church
sheet music in the hands of guests
friends, brothers, sunburnt towhead kids
in awe of the cock union.
You the bride look newly rescued
from leviathan foaled in heaven's gloss
virginal white gown downplayed to cream
and comfort Chinese silk
Hong Kong, Seoul, Bangladesh
and your man doesn't look at all bad
in the immanence of bliss and gratitude
a new start erasing the unseen scars
on our bodies all wrought in fun.
As Delmore said, the world is a wedding
you ascended the high harmonies
of wine and crystal to the great jump off the top.
Your proxy inclusion of me in this
is a bloom of courage and a shot
across the bow. I accept.
You can't win them all and in the end
the ocean. Left turn over England
farewell Holland, an almost empty plane
drinking vodka and walking in socks.

In the fairy-tale land before the tragedy
kids and grownup passengers
were invited to the cockpit. My turn came.
On the flight deck we looked forward
through green glare-proof eyes.
The KLM pilot was cool when I asked
a dumb question: "When you fly into the sun
you don't see your shadow." Indeed, the sun
drew us like a magnet, each motley visitor
alone in his own country. I salute
the lavish tie of the groom.

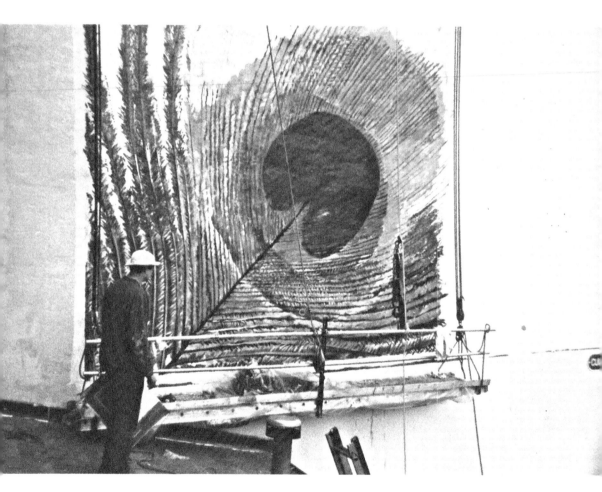

CUBISM TODAY

At a small round table for two observe
a protocol—a Greek waiter smirks,
neglects, in a crowded bistro
off Madison, our small emergency.
The afternoon
is crushing down to a plan of minutes
two fugitive friends, trying Braque
two games of solitaire, absent
thoughts—beams of light like javelins
traveling through the glass like death
on the plains of Ilium.
The small table rocks
exacerbating hangover. We split the clock
'twixt self and domestic bliss
add vector, jitters, a wry smile.

A wedge of wood would save us. The waiter
stoops to foot the table with a shim
on the level now we speak.
It's not an earthquake
just our moment in a man's world
we must eat.

The century is new as it was for Braque
but the same waiter cleans up
the stale remnants. Ash of cigar and pipe
a rind of cheese, a grape stem,
glass of aperitif, a coy vowel left behind
Picasso's sly wink.

Rituals have sharp edges—we obey.
A direct sunray strikes the gray
of a sitting gent's *Journal*
a sundial scribes the hour. The wine bottle
is capped with a weather vane: A crowing cock
or does monsieur prefer the leaping fox?

Even the shopkeepers are artists
their storefront paint abuts
with intelligence against the neighbors'
and Frenchmen reason in their pride
and manners in chosen hues:
congruent teal, olive, urbane brown
that thrive along the plumb divide.

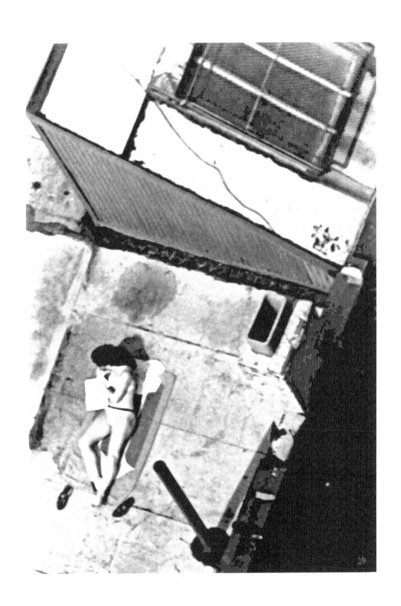

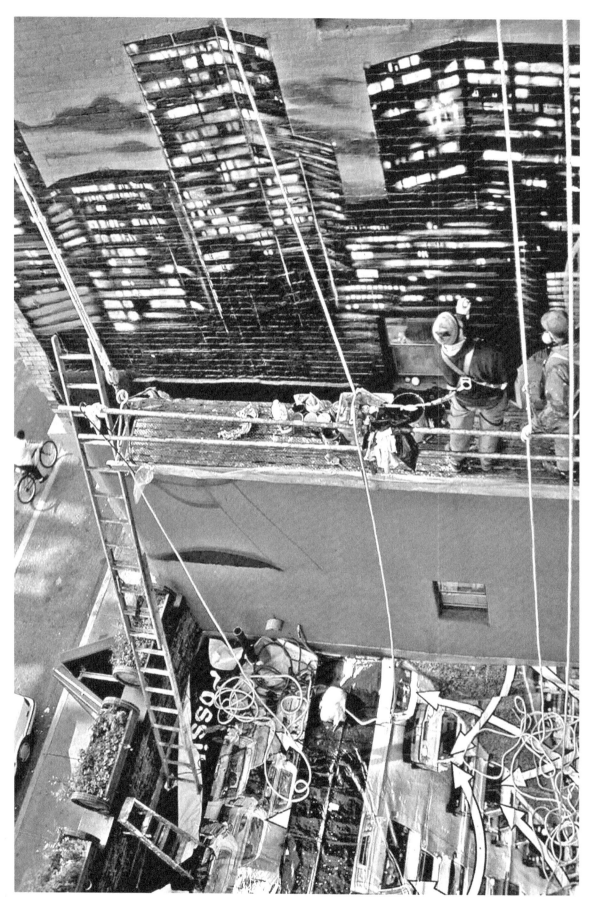

PAINTING WHISKEY

In the Beaux-Arts Academy
we were told to draw the big things
first, the breasts
the legs and hips, volume
and attitude of a delicate head—
pencil moving fast. So an upright pose
starts from plane to heel
then calf to hem
knee to hip, then
swerving top.

Below our swinging plank
as we hoist ourselves on rope
pedestrians on fast feet
commit their tasks by rote
a thousand eyes cast down the street
or searching in the sky.
Some notice us, walking by.
We paint fast—our monument to whiskey
rises above Hudson Street
saturated with vermillion, warmed
with the sun's fiery western face.
Add a splash of purple ice.
We finish the picture in a race
happy to descend the ladder
enter the evening in a happy place.

Out on the far edge
the cusp of the earth
Creation cuts a furrow
through today's last light
the date falls off the calendar
is gone, orange bleeds into indigo
as the fireball goes down

over New Jersey
as the ladies of Manhattan rest
to refresh as daisies
wash their hair, dry delicates
draw the window shades—prepare
the day's cycle all over again.

THE TOP FLOOR
(A RAKE'S PROGRESS)

Today we'll use the company's time
a window in the snow, parked beneath a viaduct
comrades on ladders overhead
who curse and laugh in fury, scraping down
a flagging Camel sign and the paper whirls away
in a blizzard of flakes and chunks to join the melee
of sleet sucked rapidly up the Boulevard's vortex
which suits our purposes just fine for tall tales
how a person's outer limit did not hold
some paragon of myth, young Abe Lincoln
a curse, unworthiness (unbearable in tall men)
myself tall and author now to retell
this youthful saga so long ago.
Ode to many gifted fallen young.

First a crew in a yellow jeep passed by and yelled
GO BACK! followed by the real thing, the bust.
Chicano rookie cop with a peach fuzz chin, the plated nickel
handcuffs matched his gun. No place up here for man on foot
the wind's music in the catwalks played an angel's harp.
For his troubles as a rake he got escorted off, tossup
nuisance misdemeanor or just bughouse, maybe ought
to let the damn fool jump.

Despair, said the young luminaire, booked my ticket.
The password was "War Debts."
Going quietly he paused with his young cop
hands cuffed in his lap and seated in the front
as on a date (in the San Francisco Police car)
they turned around at Yerba Buena then back to town.
Accustomed to high-speed chases and jack-knifed trucks
alerts for wanted felons—a kindly gatekeeper in gray
inquired through the open window, about his use of drugs.

Life in '70 not so funny with Henry hustling his fat butt
on tarmacs. Viet Nam and how from strength, to extricate.
In the memory of Lenny Bruce, comedy grew dim.
History repeats: At Versailles
we stopped the Hun and made him pay.
Abe Lincoln walked ten country miles per day
and in a snow-blind daze
in Illinois returned that beacon book.

I was a normal kid. In an Evanston backyard
my friend's dad karate-chopped an ear of corn
foil-wrapped and roasted on the spit
to demonstrate Korea. His two crazy sons
and all of us were in awe of the Marines. Unruly
we stoned the lampposts and ran
mumbled pledges at the camp
and in scout uniforms met in person
Aunt Jemimah.

From old snapshots a kind of grace
when caught off guard the handsome face
emerges in a calm not unlike arrogance.
Talent and luck took him to Yale
a shelter with good plumbing
where he could sit out that war.
In summer he sowed the seas
of his dreams with real places
Europe and the Mediterranean Sea:
Italy, Tunis, Alger, Maroc.

It was in the same clothes
in which he lunched on roast
at Phillip's with the profs, when the Bay Bridge
found him with Lee Oswald's haggard grin
unshaven, cuffed, restrained by laws.
Gray herringbone, belted in the back
white linen ducks, the Brooks shirt not pressed
but clean. Then traded for the hopeless inmate's tunic
the shoes came off, he noted with an attendant
standing by, in just what olive-colored nook was kept
his kit. There would be escape, not yet.

The cots in the Yale gym were spare and grim,
just like *Beau Geste*, the foreign legion film
and there were sepia photos of the teams and look!
That Yale man performing an iron cross
in the '36 Berlin Olympic Games.
In the Illinois snow-blind myopic trance
he was handled and led down the chemical steps
from hysteria to sleep. That first night
he heard in dreams, the icy laughter of New York.

There must have been some insult to the heart.
The meth, pastel bungalows in Oakland
seagulls wheeling in the Presidio and Golden Gate
the weight of fiction's ram horns on his head
the black musicians blowing in the Haight
all night till brunch, the proud possession of the gold
the sound, a swagger in brass, eyes on the prize.
Angela Davis, crime and protest, the bizarre newspaper
kidnap of Patty Hearst, bravado and upraised fists
against the palisades of Ronald Reagan's wooden men.

(He could not find work). The Icarus kids
on LSD were dropping in like flies.
Picasso chain-smoked his last Gauloises
Henry Miller rode his bike into the sun
Louis Armstrong put down his coronet
to swing at last in Glory. And to our rake
were other dear and sentimental loves
who also died. So a short stop at the top
of San Francisco General helped out
in the nick of time. On the darkest night
a sweet blond volunteer kept watch—she wore jeans
and a bandana—her vigilance relaxed the ward.
She watched him drop to one knee
perhaps theatrically
or did a murmur slur his heart?

Young restlessness (and Stephen Crane
was only young) was a searchlight on the China Bay
just blocks away. Whatever demons vanquished.

And all who stayed there gave thumbs up
four stars! For such compassion: gratitude.
But duly note and now surmise:
that in the calm precincts of noon
on Conrad Hilton's property
in the shopping malls and streets
a ragged spirit is unwise.

At a badly-tuned piano he met Eve
buxom sloppy red-mouthed, sisterly
(he demurred her affections)
she waited in an overcoat for some visitor
a man, her mom to come? To give a shape
and purpose to the day. She badly needed help.
It was all vanity, the horror
at twenty-five when fame had not begun
the death of a loved one, the war
a loss of sight, the fragile moment mocked by fate
but tall, exhausted godless latent tears—amphetamine
morality—no better or above (oh yes, ridicule).

He dug out. Left *without advice,* some aide would later say
found his clothes, bumped his butt against an exit door
open to the sunny world and sidewalk, blessed air.
The grin was back, headache gone
nuthouse a distant memory.
He found his red Volkswagen bus and crossed again
the same Bay Bridge to Oakland. At the Berkeley tollgate
he saw her and made the U-turn. Then in Chinatown
they sat—partners in life to be, newly met.
A quiet Buddha's gong announced their victory.

Our working day is done. We can rejoice.
I'm still here, baby.

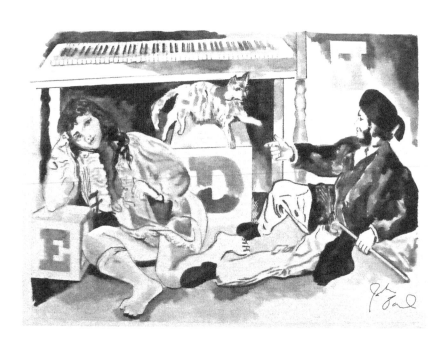

LIST OF ILLUSTRATIONS

(all art by John S. Paul except where noted)

PHOTO BY MICHAEL LEE NIRENBERG

ABOUT THE AUTHOR

John S. Paul came to New York City from Chicago in 1972 and is still Midwestern at heart. He studied at Washington University, St. Louis, which was then an art academy in the beaux-arts mold, situated in a university. In the sixties, the emphasis there was on craft, grounded in the canons of German expressionism and the Bauhaus. He went on to Yale for an MFA, where modernism was key, then was advised to go straight to New York. Instead, he taught prep school for a quiet lonely year in New England. After that term he traveled for a summer in Europe and North Africa in a new red VW bus (purchased in Amsterdam), shipped the bus to New Jersey from Marseilles, then drove across the United States to live in the San Francisco Bay Area (visiting family along the way). While touring in this same bus he met his wife Judy while she was hitchhiking in California.

In San Francisco, Paul attached himself to a drawing group with Elmer Bischoff, Joan Brown, and his classmate George Lloyd. Elmer was at the head of the West Coast figurative movement at that time, but his interest was returning to the abstract modes he had begun in the thirties. Paul reacted to the wide panorama of the California scene by painting mural-sized canvases styled from Fernand Leger—acting on a suggestion at Yale from Al Held. When Paul showed Elmer

what he was doing he called it "international!" After relocating to New York at last, Paul returned to portrait and simple genre painting: still life, interior, seen in the beautiful New York light that Matisse spoke about. But his real art was living in a whitewashed downtown loft at an affordable rent. His idols were Fairfield Porter, Alex Katz, and Larry Rivers. He shared a loft with Ilya Bolotowsky during this amazing era.

Paul found New York to be the perfect mix of environment and cultural influence. Life in the city was also full of eyesores, misery, and heartbreak. In the eighties he landed work in the novelty world of outdoor advertising, billboards, and wall signs. This job exposed him to a different, sharper, and more practical kind of talent and craft. The job also took his eye to tremendous heights, gothic viewpoints of skewed angles, and verticality.

In his work as a sign painter, Paul learned to be sharp, curious, and aware of dangerous situations—and always on the lookout for beauty. He currently writes and paints from random memories, starting with a theme, but open to dialogue with the street and his immediate life situations throughout the poem or painting being crafted. He lives in Brooklyn, NY.

Recent and Forthcoming Books from Three Rooms Press

PHOTOGRAPHY-MEMOIR

Mike Watt
On & Off Bass

FICTION

Ron Dakron
Hello Devilfish!

Michael T. Fournier
Hidden Wheel
Swing State

Janet Hamill
Tales from the Eternal Café
(Introduction by Patti Smith)

Eamon Loingsigh
Light of the Diddicoy

Richard Vetere
The Writers Afterlife

DADA

Maintenant:
Journal of Contemporary
Dada Art & Literature
(Annual poetry/art journal,
since 2008)

MEMOIR & BIOGRAPHY

Nassrine Azimi and
Michel Wasserman
Last Boat to Yokohama:
The Life and Legacy of
Beate Sirota Gordon

Richard Katrovas
Raising Girls in Bohemia:
Meditations of an American
Father; A Memoir in Essays

Stephen Spotte
My Watery Self:
An Aquatic Memoir

SHORT STORY ANTHOLOGY

Have a NYC:
New York Short Stories
Annual Short Fiction Anthology

PLAYS

Madeline Artenberg &
Karen Hildebrand
The Old In-and-Out

Peter Carlaftes
Triumph For Rent (3 Plays)
Teatrophy (3 More Plays)

MIXED MEDIA

John S. Paul
Sign Language:
A Painters Notebook

TRANSLATIONS

Thomas Bernhard
On Earth and in Hell
(poems by the author
in German with English
translations by Peter Waugh)

Patrizia Gattaceca
Isula d'Anima / Soul Island
(poems by the author
in Corsican with English
translations)

César Vallejo | Gerard Malanga
Malanga Chasing Vallejo
(selected poems of César Vallejo
with English translations and addi-
tional notes by Gerard Malanga)

George Wallace
EOS: Abductor of Men
(poems by the author in English
with Greek translations)

HUMOR

Peter Carlaftes
A Year on Facebook

POETRY COLLECTIONS

Hala Alyan
Atrium

Peter Carlaftes
DrunkYard Dog
I Fold with the Hand I Was Dealt

Thomas Fucaloro
It Starts from the Belly and Blooms
Inheriting Craziness is Like
* a Soft Halo of Light*

Kat Georges
Our Lady of the Hunger

Robert Gibbons
Close to the Tree

Israel Horovitz
Heaven and Other Poems

David Lawton
Sharp Blue Stream

Jane LeCroy
Signature Play

Philip Meersman
This is Belgian Chocolate

Jane Ormerod
Recreational Vehicles on Fire
Welcome to the Museum of Cattle

Lisa Panepinto
On This Borrowed Bike

George Wallace
Poppin' Johnny

Three Rooms Press | New York, NY | Current Catalog: www.threeroomspress.com
Three Rooms Press books are distributed by PGW/Perseus: www.pgw.com